How to draw
MANGA
FEMALE ACTION FIGURES

Peter Gray

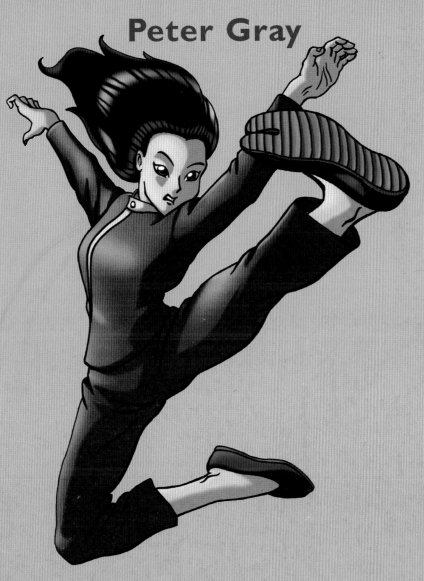

W
FRANKLIN WATTS
LONDON•SYDNEY

This edition printed in 2006

First published in 2005 by
Franklin Watts
338 Euston Road
London NW1 3BH

Franklin Watts Australia
Hachette Children's Books
Level 17/207 Kent Street
Sydney NSW 2000

Produced by Arcturus Publishing Limited
26/27 Bickels Yard, 151–153 Bermondsey Street
London SE1 3HA

Editor: Alex Woolf
Designer: Jane Hawkins
Artwork: Peter Gray
Digital colouring: David Stevenson

A CIP catalogue record for this book is available
from the British Library

ISBN 07496 6618 8

Printed in China

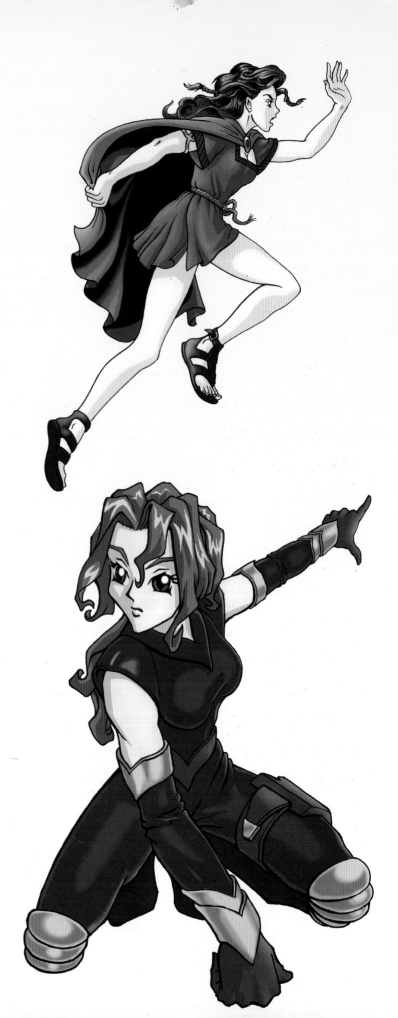

Contents

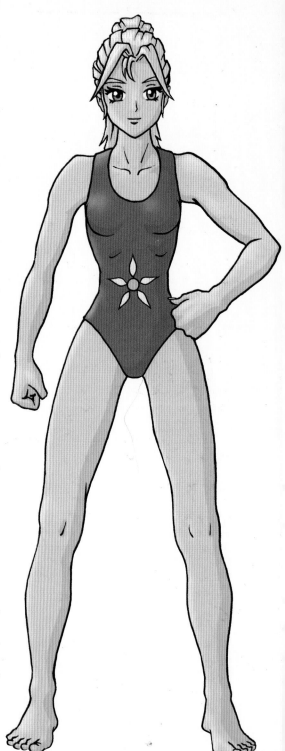

Introduction

This book shows you how to draw the types of action characters that have taken the comic world by storm in recent years and are the stars of Japanese animation (known as anime). Called manga, this style of artwork was first used in Japanese comic books. Manga is, in fact, the Japanese word for these original publications.

The style is very distinctive – dazzling eyes, angular features, simple but often exaggerated expressions, extreme gestures and super-slick colouring.

Every manga character you see in a TV programme, movie, comic or computer game starts life in exactly the same way, as a rough sketch. The artist then turns this into a black line drawing. Colour is added later.

In this book, we'll be focusing on how to draw manga female action figures. Follow all the step-by-steps and advice given in this book, and you will soon learn all the techniques you'll need to draw them. But drawing manga is more than about just absorbing the theory. To draw well in the manga style takes a lot of practice, so be prepared for some hard work, but a whole lot of fun, too. Once you've built up your skills, you'll be able to create your own original characters, and then there'll be no limit to the possibilities ahead.

You never know, one day your creations might make it onto the screen or published page!

Daisy

This is Daisy. She'll be posing for some of the drawing lessons in this book. Daisy's seventeen, and she's a pretty good manga artist herself. She's been drawing comics since she was twelve.

Daisy is also good at defending herself – something she learned from growing up on the rough side of town. But she tries to avoid fights. She'd much rather be drawing or hanging out with her friends.

Materials

Pencils are graded H, HB or B according to their hardness. H pencils are the hardest. These pencils will make lighter lines. B pencils are softer and will make darker lines. Most general-purpose pencils found at home or school are graded HB. Use a hard pencil, like an H, for sketching the guidelines you'll be drawing to help you shape your characters; using this pencil ensures the lines are easily erased later. Use a softer pencil, like an HB or B, when you're ready to pick out all the final lines of your drawings to darken them. Mechanical pencils are best, as they produce a constant fine line. If you're not using a mechanical type, make sure you keep your pencil sharpened.

An eraser is almost as important as your pencils. It means that you can draw all the guidelines you want to help you shape your characters and then erase them later. You won't have to worry about making mistakes, either. There are dozens of different types of erasers available, but they all do the same basic job. Just make sure that yours doesn't leave behind any dirty marks.

Don't worry too much about the type of paper you use. Most of the drawings in this book were done on cheap photocopier paper. Only if you're working with paints should you purchase thicker paper since it won't tear or buckle when it gets wet.

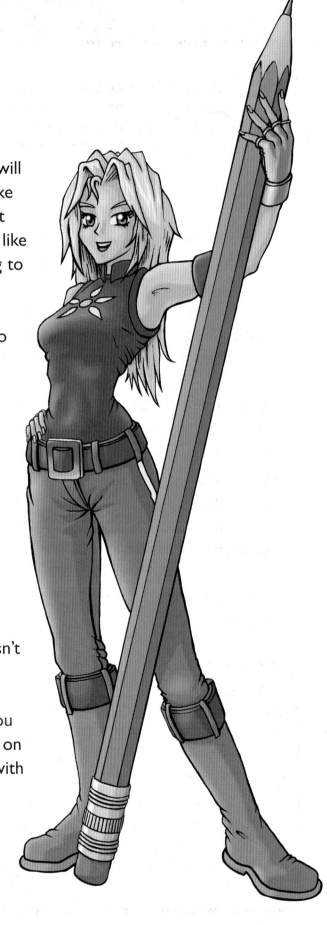

The Figure

The human body is a very complex machine, with bones, muscles, fat and skin all working together. However, to draw a manga-style body, you just need to learn a few basics about the structures that lie beneath the skin. You'll find that your drawings of the outside appearance of the body will be easier to construct if you understand what goes on inside.

The Skeleton

Think of the skeleton as a frame upon which you can hang muscles, skin and clothing. Think about the basic structure. The body is able to bend because of the joints. The arms have shoulder, elbow and wrist joints, while the legs have hips, knees and ankles.

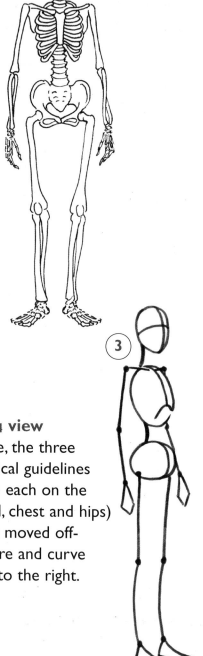

1 Front view

This is a simplified version of Daisy's skeleton. Draw the head, chest and hips as simple oval shapes, separated by short vertical lines. Her arms do not hang directly from the chest but are separated by shoulder bones, while the legs are joined onto the hips. Draw the joints as small dots.

2 Side view

When Daisy is seen side on, some of the features get thinner or disappear from view. From this angle, her back is slightly arched. The arms are slightly bent and the leg bones curve.

3 3/4 view

Here, the three vertical guidelines (one each on the head, chest and hips) have moved off-centre and curve out to the right.

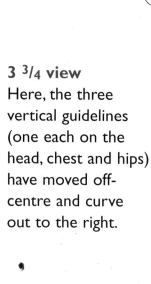

Muscles

Here's Daisy's skeleton again with an outline drawn around it to show how the flesh and muscles wrap around the bones. Like most manga women, Daisy has a muscular, athletic look. Her outline mostly follows the shape of the skeleton, but the powerful muscles over the shoulder joints and on the thighs curve out more. The outline tapers in at the joints. Some parts of the body have no muscle, so you can notice the bones under the skin. These parts are highlighted with red dots.

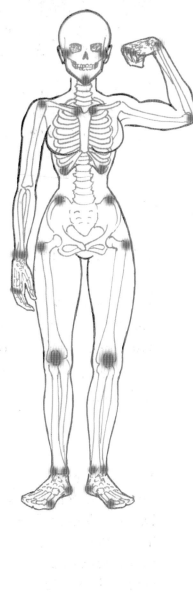

1 Side view
Notice how the outline curves at the top of the leg at the front for the thigh muscle. Lower down, it curves in the opposite direction for the calf muscle.

2 ³/₄ view
The lines showing the curves of the muscles on one leg follow the shape of the lines on the other leg.

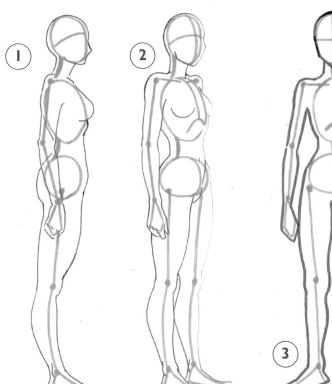
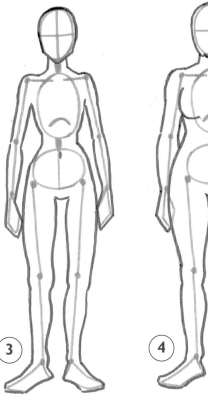

3 Thinner characters
To make your character thinner, draw the body outline closer to the skeleton and make your pencil line more angular, to reduce the bulges.

4 Larger characters
To give your character a larger build, make the outline curve more. The skeleton remains the same for these different body types.

Front View

Daisy has volunteered to stand very still while we draw her body.

Step 1

Start with a vertical line to make your picture symmetrical. Draw Daisy's egg-shaped head at the top. The chest shape is like a large oval with a chunk taken out to show the shape of the ribcage. An oval lying on its side makes the hips. Leave space between the three shapes for the neck and stomach.

Add the arms and legs. Draw the two collarbones coming out of the chest. Marking the joints will help you get the proportions of the limbs right. The legs are much longer than the arms. The wrist joint is level with the joints at the top of the leg when her arm is straight.

Step 2

Draw some curves around the major bones to mark where the flesh and muscles will go. Remember that the thighs will be broader than the calves. The upper arms should be slightly broader than the forearms. Draw in the neck and shoulders too.

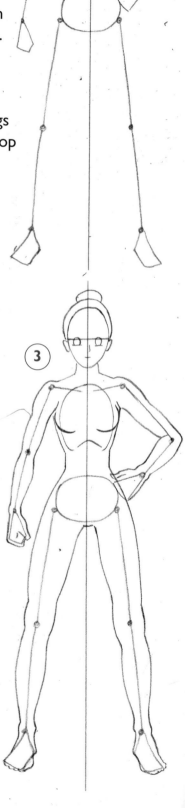

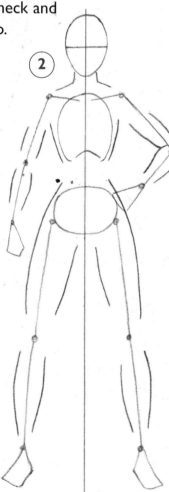

Step 3

Now fill in the missing parts of your outline. Curve out your lines to make the shoulders look strong. The outline curves in at the elbows and wrists, with a little kink on the outside of each wrist to show the bone. Draw some curves for the chest and add the lines of the waist. Give the knees and ankles a slight bulge at the sides. Shape the hands and add the feet. Finally, start outlining the features on the head.

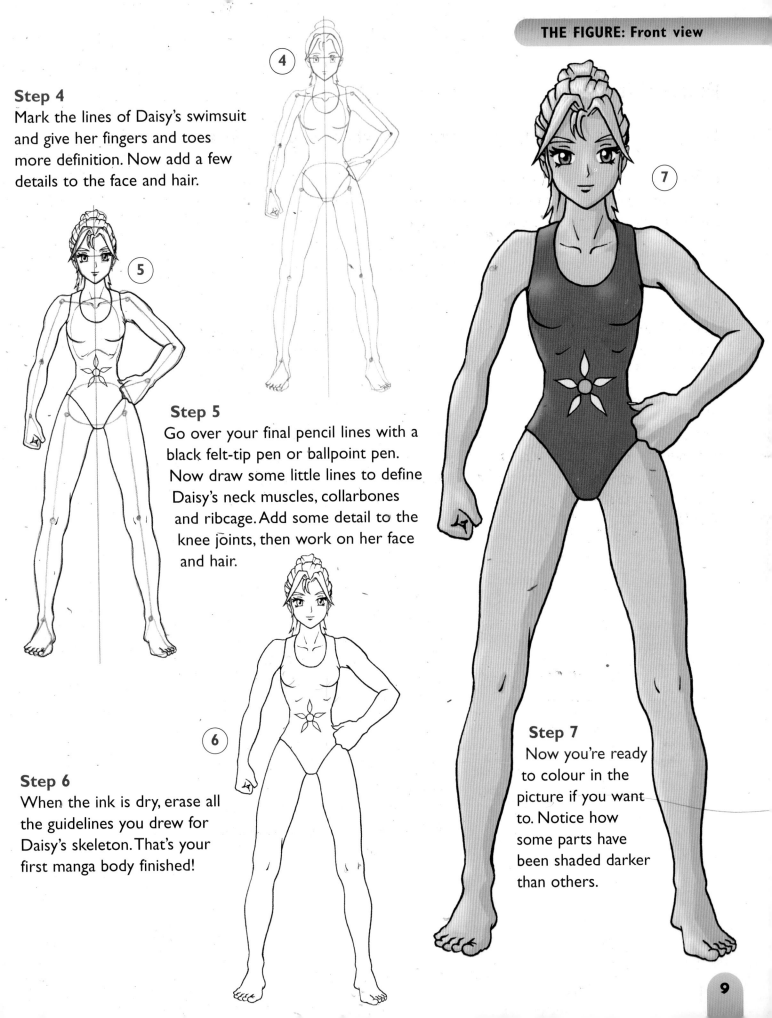

Step 4
Mark the lines of Daisy's swimsuit and give her fingers and toes more definition. Now add a few details to the face and hair.

④

⑤

⑦

Step 5
Go over your final pencil lines with a black felt-tip pen or ballpoint pen. Now draw some little lines to define Daisy's neck muscles, collarbones and ribcage. Add some detail to the knee joints, then work on her face and hair.

⑥

Step 6
When the ink is dry, erase all the guidelines you drew for Daisy's skeleton. That's your first manga body finished!

Step 7
Now you're ready to colour in the picture if you want to. Notice how some parts have been shaded darker than others.

9

Profile

Daisy has turned to the side and changed her pose slightly. Now you can see one arm but both legs.

Step 1

Draw the basic shapes of the head, chest and hips, carefully copying where they sit in relation to one another. The head is quite circular from this angle and sits slightly ahead of the chest and hips. The oval of the chest tilts backwards at the top. From this angle, the hips form a circle shape. Add the neck and lower part of the spine. Add the limbs. Start by marking the joint at the top of the arm to help you position the collarbones and arm bones correctly. When you draw the legs, notice how the calf bones curve to give the legs a more glamorous profile. Just draw rough outlines of the hand and feet for now.

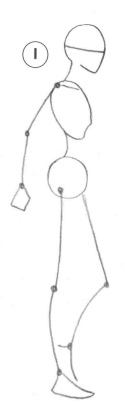

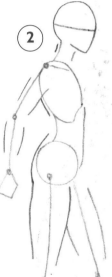

Step 2

Draw some rough lines around the main bones of the body for the flesh and muscle. It's very important that you get these right before you complete your outline.

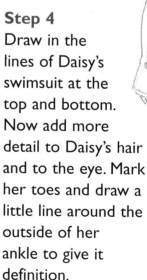

Step 3

Fill in the gaps of your outline. Curve in and out around the joints. Add the hand and the feet. When you outline the hair, notice how the ponytail falls down at the back so you can see the bottom of it between Daisy's arm and the arch of her back. Now place her facial features.

Step 4

Draw in the lines of Daisy's swimsuit at the top and bottom. Now add more detail to Daisy's hair and to the eye. Mark her toes and draw a little line around the outside of her ankle to give it definition.

Step 5

Draw over the main lines of your picture in heavy pencil, adding more detail to the hair, face, hands and feet as you go along. Don't forget the flower on Daisy's swimsuit. You'll only be able to see half of it from this angle. Go over your heavy pencil lines with a black ballpoint or felt-tip pen.

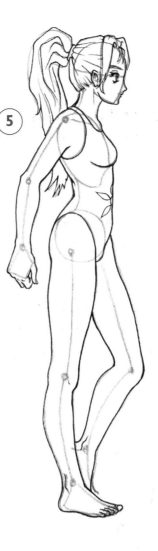

Step 6

Once the ink is dry, erase all the pencil lines of your skeleton framework.

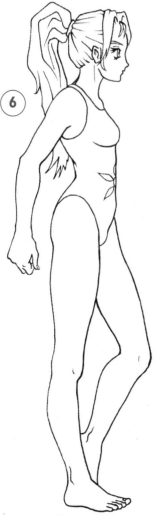

Step 7

Now you can colour in your picture if you want to. Try experimenting with different colour schemes to change Daisy's hair colour, skin tone and swimsuit design.

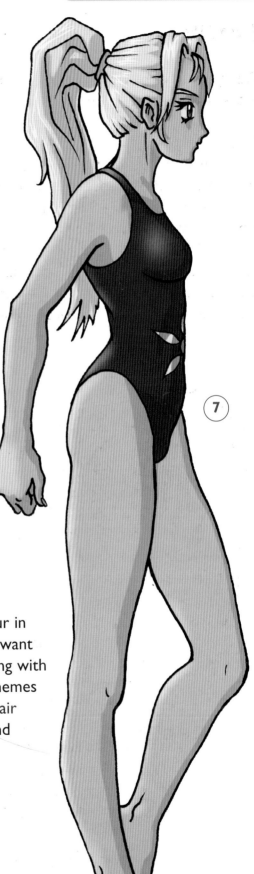

3/4 View

In addition to standing at a different angle, Daisy has changed her pose again, so she now appears as if she is walking.

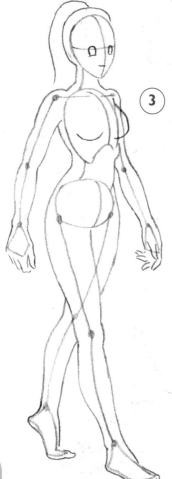

Step 1
Using light pencil lines, draw the head, chest and hip shapes as shown. Draw a curved vertical line on each of these body parts. Add curved lines for the neck and lower part of the spine. Add the bones and joints of the limbs. The lines for the legs should cross over each other as shown. Copy the shape of the back foot to show how Daisy's heel is raised.

Step 2
Add the main lines that mark the flesh and muscle around your skeleton framework. When you are drawing Daisy standing at this angle, one of the neck guidelines is further away from the guideline for the spine than the other one. The same will be true for the waist in the next picture.

Step 3
Fill in all the gaps around Daisy's body outline, including the hands and feet. Now add the lines for her chest, hair, eyes and mouth.

Step 4
Draw in the lines of Daisy's swimsuit. Give the fingers and toes some definition, then work on the hair and face.

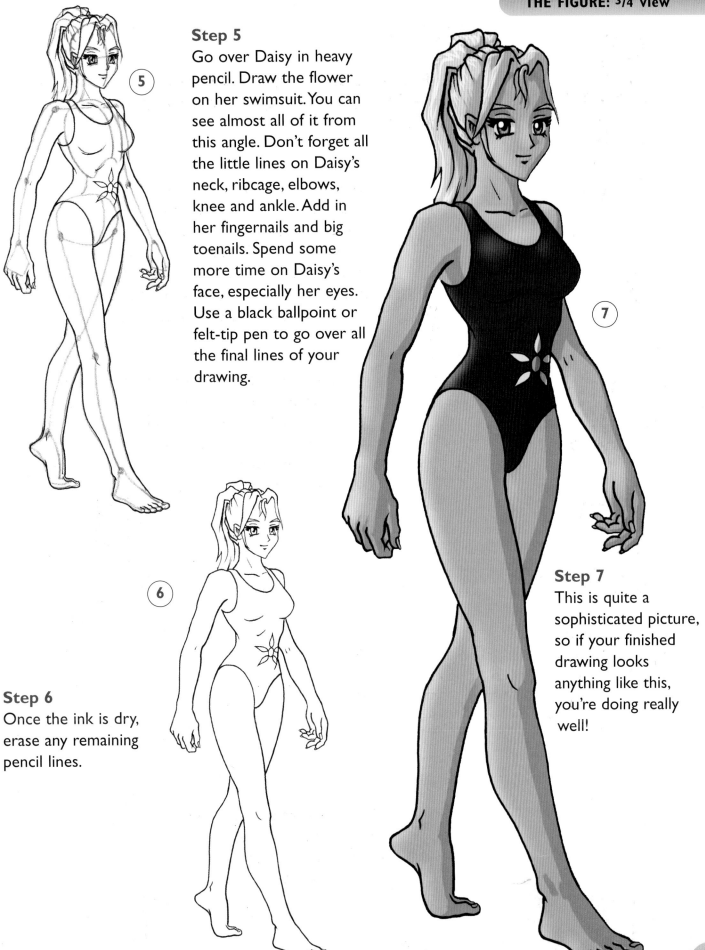

(5)

Step 5
Go over Daisy in heavy pencil. Draw the flower on her swimsuit. You can see almost all of it from this angle. Don't forget all the little lines on Daisy's neck, ribcage, elbows, knee and ankle. Add in her fingernails and big toenails. Spend some more time on Daisy's face, especially her eyes. Use a black ballpoint or felt-tip pen to go over all the final lines of your drawing.

(7)

(6)

Step 6
Once the ink is dry, erase any remaining pencil lines.

Step 7
This is quite a sophisticated picture, so if your finished drawing looks anything like this, you're doing really well!

Hands

Hands are not easy to draw, but mastering how to draw them will give your pictures an expert quality. Just like the rest of the body, they can be broken down into basic shapes.

Step 1
To draw the back of the hand, you need to draw a rough outline of the overall shape before you add the individual bones. The shape is a bit like a fan.

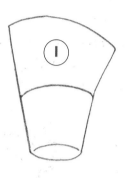

Step 2
Draw a large circle at the bottom to form the wrist bone, then draw the finger bones and joints radiating out from this. The bones are the straight lines and the circles are the joints. The thumb sticks out to the left of your original shape.

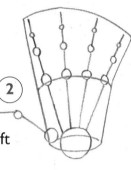

Step 3
Draw around the bones to add the flesh and muscle. Make the outline more curved around the fleshy parts of the thumb.

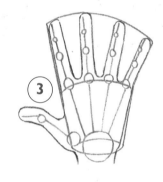

Step 4
Draw on the fingernails and some little lines to define the knuckles.

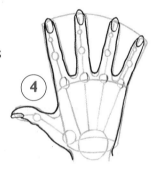

Step 5
Use a black ballpoint or felt-tip pen to go over the final lines of your drawing again. When the ink is dry, erase all the pencil lines of your original framework.

Artists often use their own hands as models. Practise drawing your spare hand. Try rotating it so you can draw it from different angles. Look at it in the mirror too.

Hands in Action

There's not much a person can do with their hands if they keep them flat all the time, so you will need to learn how to draw hands from all kinds of different angles, in all sorts of positions.

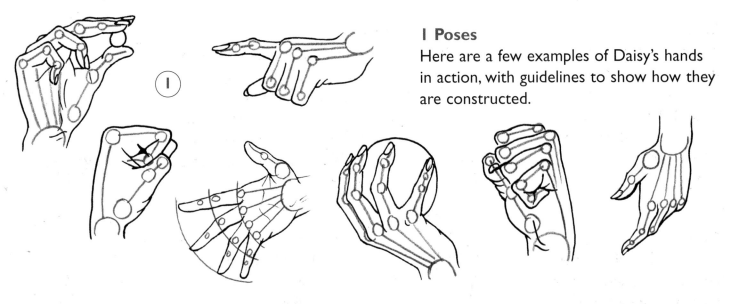

1 Poses
Here are a few examples of Daisy's hands in action, with guidelines to show how they are constructed.

2 Simplifying hands
Cartoonists have many different ways of simplifying hands. Try out each of these styles.

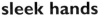
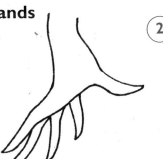

sleek hands

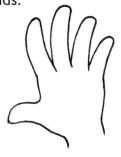

simple hands

3 Different ages
These hands belong to characters who are very different in age. The baby's hands are chubby, so the bones and joints aren't very defined. The older hands have less flesh, so they look more bony and wrinkled.

baby hand

old hand

Proportions

The proportions of the body change as a person gets older. Manga artists work out the relative sizes of their characters using head lengths. These pictures show Daisy at four different ages.

1 Toddler Daisy

The younger a character is, the larger her head will tend to be in relation to the rest of her body. At about three years old, Daisy's whole height is four times the height of her head. She is quite chubby.

2 Preteens

At around nine years old, Daisy is about six heads in height. Her body is more skinny than when she was younger.

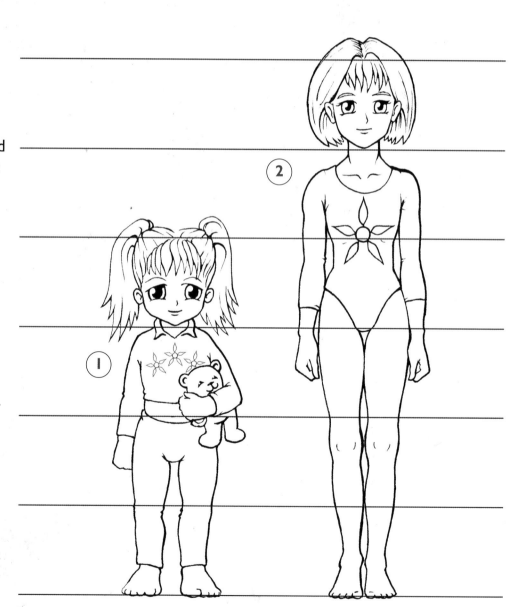

3 The teenager

Daisy is now seventeen, so she is nearly fully grown. She's seven heads tall. Some manga adults are also around this height. Compare Daisy here with the pictures of her when she was younger and see how much more developed her muscles are now.

4 Adulthood

This is Daisy at her fully grown adult height of eight heads. Not only is she taller, but her body is broader at the hips and her limbs are more curvy. Real human beings are rarely eight heads tall, but this is very common in manga stories. Manga females of eight or more heads in height are usually fashion models or action heroines.

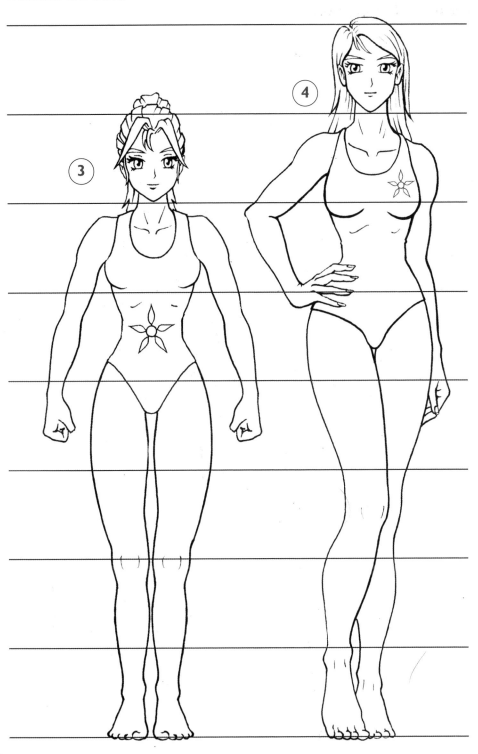

It is uncommon for female characters to be heavily muscled, even if they are dynamic action types. Their bodies are more often tall and graceful.

Clothing

Every item of clothing will fall, fold, hang and wrinkle slightly differently because of its shape and material.

1 Everyday clothing

The clothing here is loose. This emphasizes the effects of the body's movement upon it. Where the limbs are bent at the knees and elbows, the cloth gathers into tight folds. Where the limbs stretch, the cloth is pulled tight but still forms wrinkles. Notice how raising an arm causes the fabric under the armpit to form folds that radiate away from the joint.

2 Tunics and capes

Manga characters are often dressed quite differently from real people. They might have flowing garments like tunics and capes. When the character is standing still, all the folds will hang vertically due to the pull of gravity. In this sketch, you can tell there is movement or wind affecting the cape, causing the folds to flow in different directions.

3–5 Materials and shape

Think about the weight of the cloth. A thicker fabric, as in picture 3, makes bigger folds. Folds also occur where the fabric is loose-fitting, as in picture 4. Manga characters often wear tight-fitting clothes which have simple wrinkles, as in picture 5. These are easy to draw, as long as you have drawn the body underneath them well.

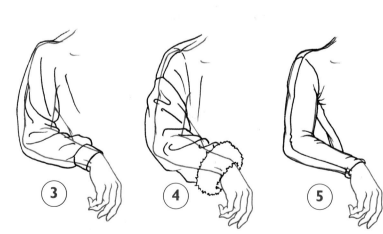

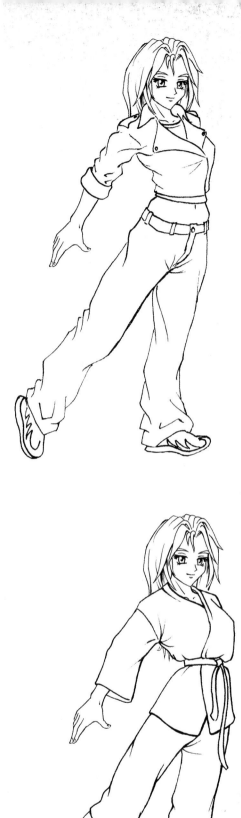

Manga Style

The clothes you choose to give your manga characters can say a lot about their personality as well as when and where they live. Here Daisy is modelling some typical manga outfits. There is not much detail in these drawings and no colour or texture, but you can still tell from the folds and creases that they are made from different materials and that the style of the clothing also affects the way it hangs on her body.

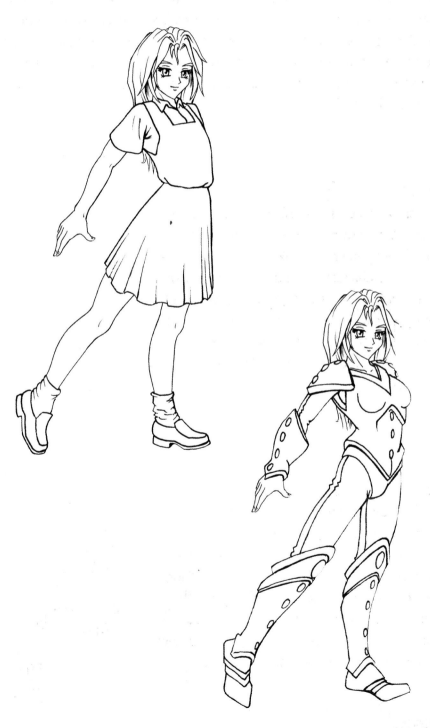

Action

Capturing the movement and look of a character's body and clothing is the key to drawing convincing action figures. Getting these right has a lot to do with studying features closely, so in this section we'll think more about body language, movement and perspective. We'll also look at the technique of foreshortening to enhance your pictures.

Here it is more important than ever to start with light pencil lines that you aren't afraid to change until you get your picture right. So let's get down to some action.

Body Language

Everyone displays body language in everything they do throughout the day. Often this can be quite subtle, but in manga there's no place for subtlety! In each of these rough sketches, the character shows a lot of emotion through her pose. Try copying some of the poses.

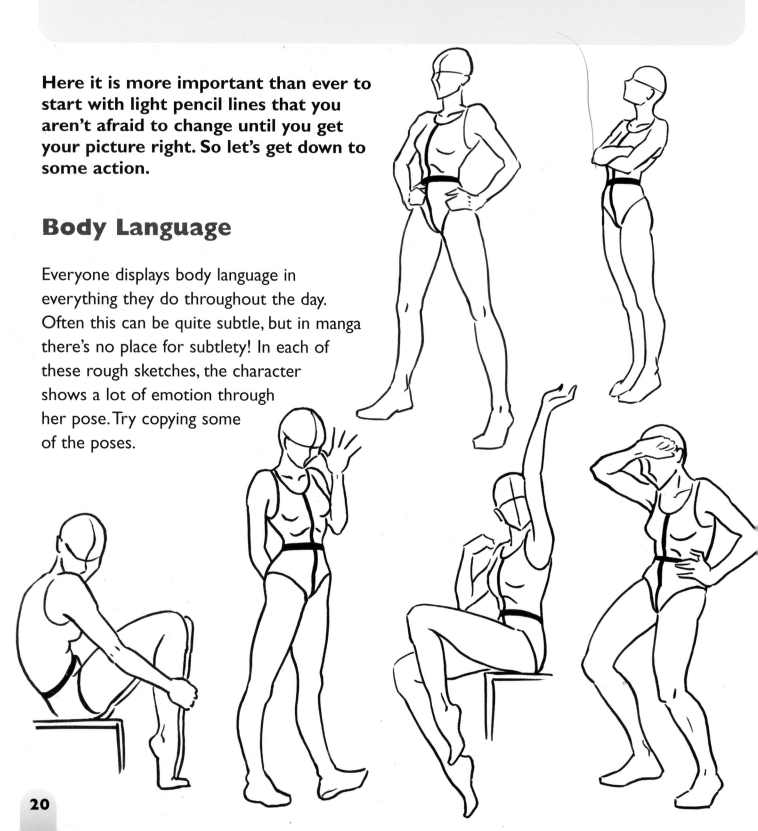

Movement

The pose of the body can also be used to show movement and action. There's a whole range of poses you can devise for manga figures, but to make the figures look realistic, they should bend in the same way that a real person's body bends. Shoulders, wrists and ankles can swivel in many directions, for instance, but knees and elbows can't bend backward or sideways. Use your own body to try making a pose you want to draw to see if it's really possible!

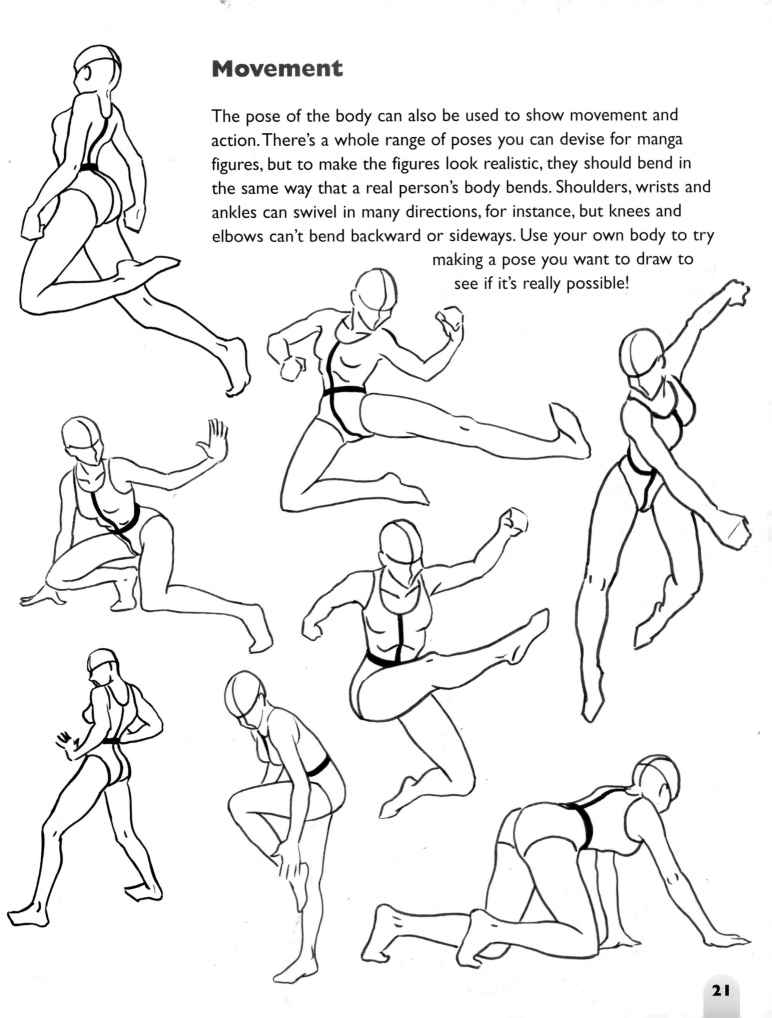

Running Girl

Our manga character Lunara is running fast. The main thing about her pose is that it's not balanced. If you tried to stand like this yourself, you would fall over. That imbalance helps give the impression of movement, together with the flowing hair, skirt and cape.

Step 1

Draw the three main body parts of Lunara's skeleton first. You are drawing her body from the side but with it leaning forward so the body parts follow a diagonal line. Now add the limbs. Lunara is very tall, so her arms and legs are extra long.

Step 2

Draw the outline shape of Lunara's flesh and muscle. Use strong curves in the shape at the backs of the legs to show Lunara's strong muscles.

Step 3

Add some basic lines for Lunara's tunic and cloak. Add the main features of the face and some of the curves of the hair. Work on the shape of the feet.

Step 4

Give the clothing more detail. Notice the square-shaped neck of the tunic. Add a belt, then draw some lines along the bottom of the skirt and cloak to show the folds. Work on the hands and feet. Lunara is wearing sandals, so you'll still be able to see her toes in the final picture.

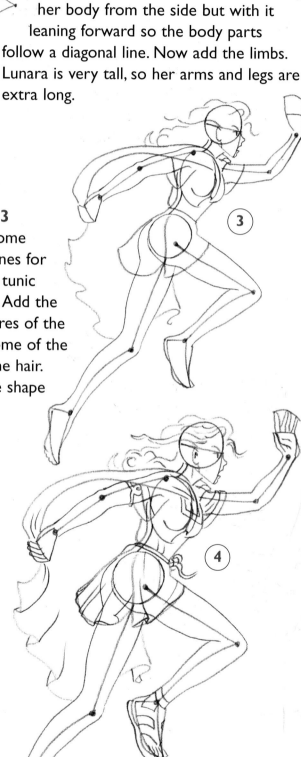

Step 5

Once you're happy with your drawing, go over your pencil lines in black ballpoint or felt-tip pen. Now add some shading to the hair to give it more depth. Add some plaits. Work on the design of the neck of the tunic. Add accessories such as a brooch to secure the cape, a rope belt and a buckle on one of her sandals.

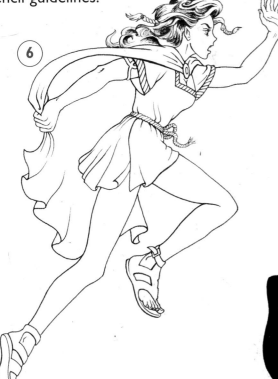

Step 6

Leave the ink to dry, then erase all your remaining pencil guidelines.

Step 7

Now you can add colour to your picture. Here she's been given auburn hair and fair skin. Notice how dark the inside of the cloak is, where it is in shadow.

Perspective

When artists talk about perspective, they mean that objects look different according to the angle, height or distance from which we view them. In all the pictures on this page, the figure is holding exactly the same pose.

Figure 1
When viewed from the front, the figure appears to be resting the box on her foot.

Figure 2
From the side, we can see that the box is actually some distance in front of the figure's feet.

Figure 3
Looking at our character from behind means the hips are closer to us and so appear wider. The waistband curves down at the ends. In figure 1, it curves up.

Figure 4
Now we are looking down on our figure. It is below our eye level, so all the parts of the picture that look level in figure 1 now slope up the page, as shown by the blue lines. The further below our eye level the blue line is, the steeper its slope.

Figures 5 and 6
Here only some parts of the pictures are below our eye level (green line), some are above it, and others are directly at eye level. Some of the blue lines therefore slope up, some slope down, and others are roughly horizontal.

Foreshortening

Another technique that is used to make manga figures look more dynamic is foreshortening.
This is when the parts of a figure that point towards us look shorter than the ones we are viewing from the side.

Figure 1
The lower legs and feet are missing from this picture from this viewpoint. Because we know what bodies usually look like, we imagine that they are hidden behind the thighs.

Figure 2
This figure's upper body has been made shorter to make it look like it is bending forwards as the figure runs towards us. The raised shin appears very short, but we accept that both legs are really the same length. We also assume that the figure's hands are equal in size, even though one is closer and therefore larger.

Figure 3
Feet are about as long as the head, but here they are drawn half the size, because they are twice as far away.

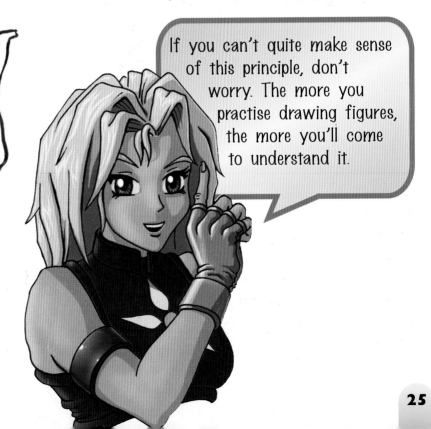

If you can't quite make sense of this principle, don't worry. The more you practise drawing figures, the more you'll come to understand it.

Crouching Girl

This drawing involves foreshortening. Our manga character, Elise, is crouching down. She twists her upper body to lean forward, and rests one hand on the ground to help her balance.

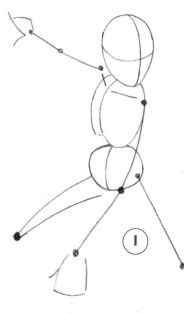

Step 1
From this angle we won't see much of Elise's neck and stomach, so make the ovals for her head, chest and hips overlap each other. Add the limbs, making sure you slope the collarbones. The bones of the front arm should be made longer than those of the back arm to make it appear closer. The hand on this arm should also be bigger. Copy the leg bones carefully. One calf bone is missing because the lower part of the leg is hidden.

Step 2
Draw the shapes of the flesh and muscle around the skeleton. The shoulders are not level, and this affects the way the chest curves. The long front arm appears broader than the back one. Carefully copy the bend in the leg on the left in your picture.

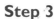

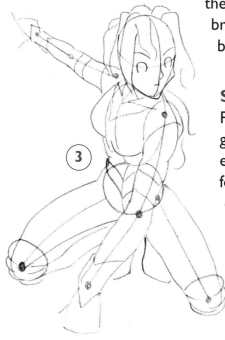

Step 3
Place the facial features. Your guidelines will help you to place the eyes correctly. Add some guidelines for the hair. Start to mark the clothing. Elise's suit fits her body closely, so you won't need to draw its whole shape. Add the extra details like the knee pads and belt. Draw in the parts of the feet you can see.

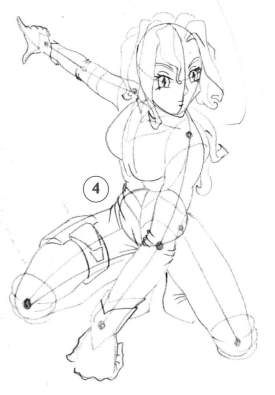

Step 4
Add some more detail to the face and hair, then work on the hands. Now add some crease lines to the clothes and a holster around Elise's leg.

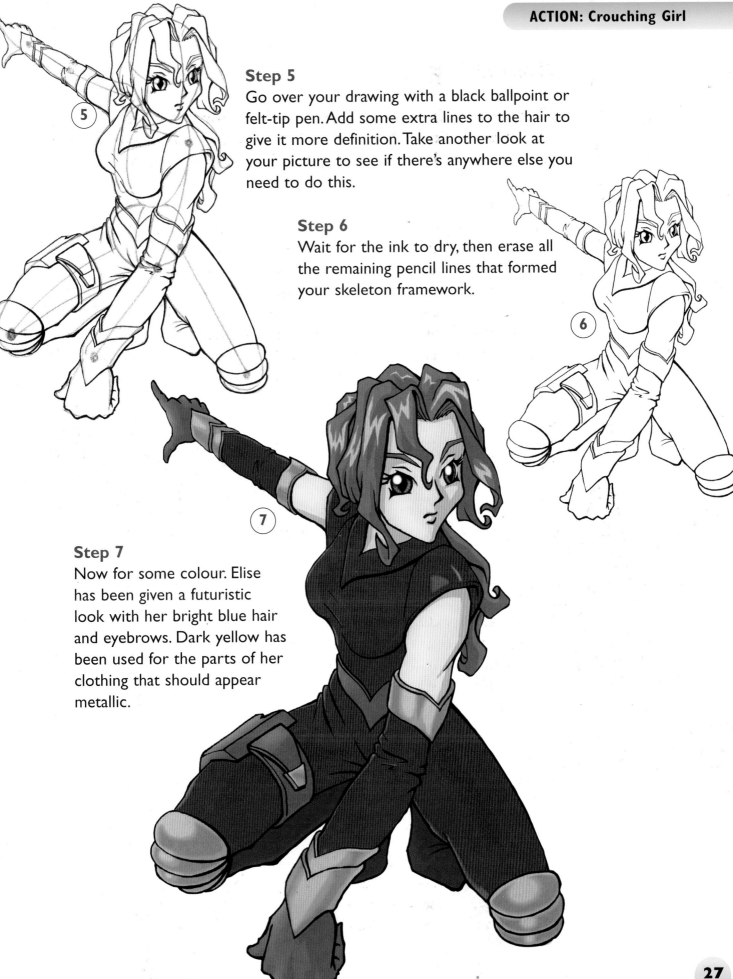

Step 5

Go over your drawing with a black ballpoint or felt-tip pen. Add some extra lines to the hair to give it more definition. Take another look at your picture to see if there's anywhere else you need to do this.

Step 6

Wait for the ink to dry, then erase all the remaining pencil lines that formed your skeleton framework.

Step 7

Now for some colour. Elise has been given a futuristic look with her bright blue hair and eyebrows. Dark yellow has been used for the parts of her clothing that should appear metallic.

Karate Girl

Let's apply the idea of foreshortening to a drawing of manga action girl Jenna, who is practising karate.

Step 1

Start by drawing the three main body parts. Take the time to position them accurately since everything else hinges on them. Next attach the limbs. Copy the proportions of them as they are drawn here. The back arm should be shorter than the front one, with a smaller hand. The front leg will have an oversized foot attached to it.

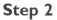

Step 2

Now draw the outline for the flesh and muscles. Notice how the front leg appears broader than the back one. Place the eyes. Jenna is looking down towards her front foot.

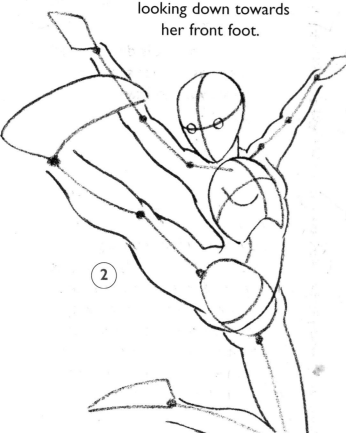

Step 3

Sketch in the clothing following the outline of the body. The suit is quite loose-fitting so it doesn't curve in around the joints. Draw the hair flying up behind the head. Place the rest of the facial features. Spend some time on the hands. Hold your own hands in the same kind of karate pose and study the positions of the fingers.

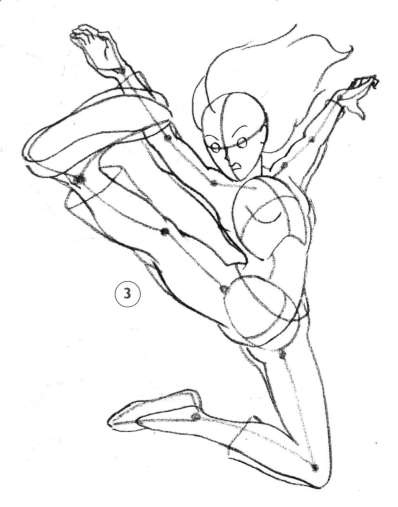

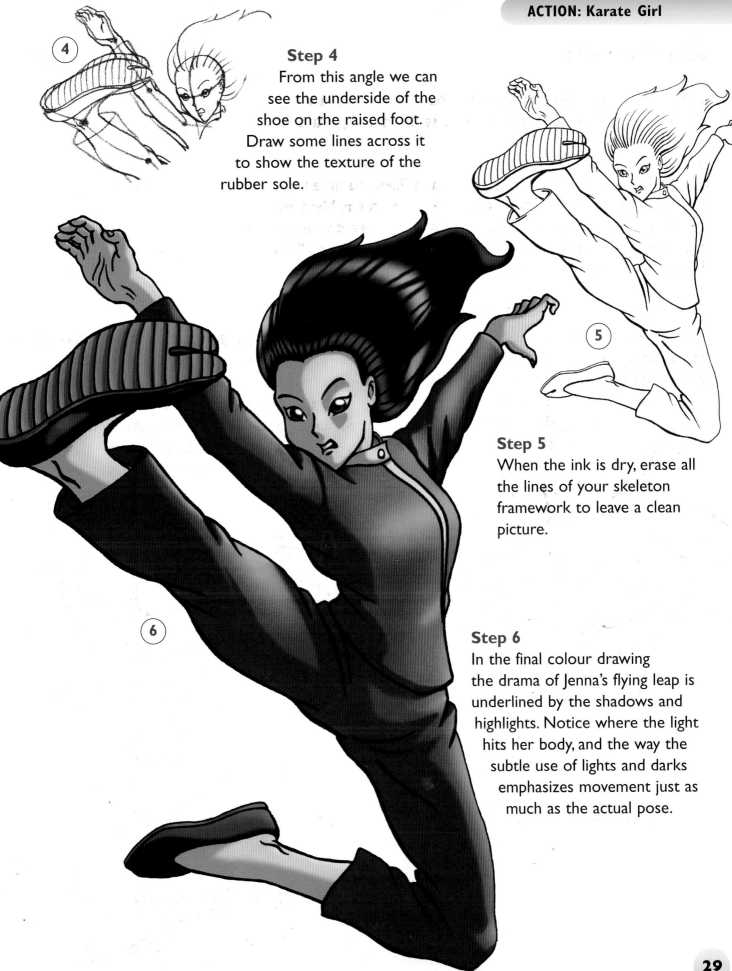

Step 4

From this angle we can see the underside of the shoe on the raised foot. Draw some lines across it to show the texture of the rubber sole.

Step 5

When the ink is dry, erase all the lines of your skeleton framework to leave a clean picture.

Step 6

In the final colour drawing the drama of Jenna's flying leap is underlined by the shadows and highlights. Notice where the light hits her body, and the way the subtle use of lights and darks emphasizes movement just as much as the actual pose.

Glossary

angular Having angles or sharp corners.

body language Bodily postures that can be seen as showing a person's feelings or emotional state.

calf The fleshy part at the back of the leg, below the knee.

collarbone The long curved bone that connects the upper part of the breastbone with the shoulder blade at the top of each shoulder.

definition The clarity of an image.

dynamic Full of energy.

foreshortening In drawing, making something appear shorter than it actually is in order to create a three-dimensional effect.

framework Structure.

highlight *noun* An area of very light tone in a painting that provides contrast or the appearance of illumination.

highlight *verb* Draw attention to something, or make something particularly noticeable.

horizontal Parallel to the horizon.

joint Any of the parts of the body, such as the knee, wrist or elbow, where bones are connected.

manga The literal translation of this word is "irresponsible pictures". Manga is a Japanese style of animation that has been popular since the 1960s.

perspective In drawing, changing the relative size and appearance of objects to allow for the effects of distance.

proportion The relationship between the parts of a whole figure.

radiate Spread out.

relative Considered in comparison to something else.

ribcage The bony frame formed by the ribs around the chest.

swivel Turn freely on a circle.

shin The front portion of the leg from below the knee to above the ankle.

taper Become gradually narrower at one end.

texture The feel or appearance of a surface.

tone The overall blend of colour, light and shade in a painting.

vertical Upright, or at a right angle to the horizon.

Further Information

Books

How to Draw Manga: A Step-by-Step Guide by Katy Coope (Scholastic, 2002)

How to Draw Manga: Compiling Characters (Volumes 1 & 2) by the Society for the Study of Manga Techniques (Japan Publications Trading Company, 2000)

Step-by-Step Manga by Ben Krefta (Scholastic, 2004)

The Art of Drawing Manga by Ben Krefta (Arcturus, 2003)

Websites

http://www.polykarbon.com/
Click on "tutorials" for tips on all aspects of drawing manga.

http://omu.kuiki.net/class.shtml
The Online Manga University.

http://members.tripod.com/~incomming/
Rocket's How to Draw Manga.

Note to parents and teachers:

Every effort has been made by the publishers to ensure that these websites are suitable for children and contain no inappropriate or offensive material. However, because of the nature of the Internet, it is impossible to guarantee that the content of these sites will not be altered. We strongly advise that Internet access is supervised by a responsible adult.

'Bye everyone! I hope you had fun learning how to draw manga.

Index